SOUVENIRS OF THE MIND

SOUVENIRS OF THE MIND

MANAL.M

PARTRIDGE

Copyright © 2017 by Manal.M.

ISBN: Softcover 978-1-5437-4035-6
 eBook 978-1-5437-4038-7

All rights reserved. No part of this book may be used or reproduced by any means, graphic, electronic, or mechanical, including photocopying, recording, taping or by any information storage retrieval system without the written permission of the author except in the case of brief quotations embodied in critical articles and reviews.

Because of the dynamic nature of the Internet, any web addresses or links contained in this book may have changed since publication and may no longer be valid. The views expressed in this work are solely those of the author and do not necessarily reflect the views of the publisher, and the publisher hereby disclaims any responsibility for them.

Print information available on the last page.

To order additional copies of this book, contact
Toll Free 800 101 2657 (Singapore)
Toll Free 1 800 81 7340 (Malaysia)
orders.singapore@partridgepublishing.com

www.partridgepublishing.com/singapore

Contents

Preface .. vii
Inner Exquisiteness .. 1
Enigmatic Moon .. 2
Contented ... 3
Jester Time ... 4
Art .. 5
My Powerful Weapon ... 6
Doleful Domain .. 7
Thank You .. 8
Times Have Changed ... 9
Nothing Lasts Forever .. 10
New Year .. 11
Sagacious Thoughts ... 12
A Woman .. 13
Relinquish Pain .. 14
Pitiful World ... 15
I love You ... 16
Can You Trust Me? ... 17
Mesmerizing Eyes .. 18
Soothing Melody .. 19
Tangled .. 20
Broken Promises-1 ... 21
Broken Promises-2 ... 22

Wrecked	23
An Ardent Desire	24
What if?	25
Ungrateful	26
Poignant	27
Resent	28
I'm sorry	29
Will To Be Emancipated	30
A Wish	31
Missing Allure	32
Who Do I Have To Be?	33
Churlish Networks	34
Painful Memories	36
Exasperated	37
Worthless Declare	38
Hopes	39
Gaoled	40
Buried Feelings	41

Preface

"In this bright future, you can't forget your past"- Bob Marley

I could never have imagined that a day would come when I would be publishing a book of my poems. This book contains poems of various genres and most of them are from experiences of my own personal life. There are a lot of times when I find it difficult to express myself but I feel that my poems help me get the job done.

I have always been very fond of poetry and had started writing when I was 13. My friends had always asked me to publish them however I was quite shy, I knew my poems were not perfect and I feared a lot that they would be negatively judged.

However as time passed by I started to gain a little more confidence in my writing, then once again my close friends recommended I get a book published. After months of nagging me I finally agreed, to which I am immensely grateful. I would specially like to thank my mother, **Dr.Samia Roohi** who supported me without any hesitation and my close friend **Joanne Biju Justus** who helped me and gave me courage in this journey, who taught me a lot of things that I can never thank her enough for, the poem '**Thank You**' is dedicated to her. I would also like to thank my friends **Surya R.K, Ivy, Eshani.M, Sana.A, Sneha, Mariah.R, and Shreya.N.**

Most of all I would like to thank my grandparents who have showered me with love and gave me blessings. I thank them for supporting me in every possible way no matter what I wanted to do. Thank you **Nanu** and **Badimama**, I love you both a lot. I am thankful for your love that you have given me throughout my childhood and I hope you both continue to stay proud of me.

Another poem '**I Love You**' is also dedicated to a close friend, who has honestly been my backbone in this journey, who takes care of me and respects me. I truly love them to bits and can basically not exist without them, this

book would have not been possible without their support. I have never met a person so admirable in my life, I thank you very much.

Sorry if I missed someone out, I truly appreciate everyone's love for this book and support for it. I hope you all can relate with these small collection of **40** poems which are very dear to my heart. A lot of this poems were written with a lot of emotions so I hope you can give them a lot of love.

Inner Exquisiteness

"Beauty is within you, remember that for life
Things will change in you from the outside
But never forget the inner you that doesn't show itself and hides.
Hearts are what matter not your makeup on point.
Perfect your inner because you might never be satisfied with the way you look on the outside
Be nice, be bold, and don't think you're not good enough for this world.
A beautiful heart is always better than a painful dart.
A weapon can kill but words can fix. What is broken needs to be dealt with.
Being perfect makes you less of a human, everyone has flaws but learn to accept them.
Be proud of what you do, be grateful for things you have.
It is what will prevent you from being pessimistic in this life.
Be positive and spread that vibe, it makes people around you smile.
Won't that make you happy? Reflect on it a bit.
Maybe sadness can be overcome just by doing all this."

Enigmatic Moon

"I exhaled as I saw the night sky
As I notice that the moon has said good-bye
Why does it leave every two fortnight?
Does it feel ashamed of the humans pathetic might?
Or is it intimidated by the stars that shine so bright?
Does it not like the darkness of the night even though it allows it to be the star with full delight?
Does it hate the light the sun provides as it makes him feel that he alone cannot survive?
Does it dislike its own colour as it's not bright like the others?
Does it not feel loved because nobody at night is up?
Does it feel lonely when the stars go away?
Is that the reason why to look for them it disappears every two fortnight?
Whatever the cause he only takes a short pause
And comes back after a while
Safely and smiling for another two fortnight."

Contented

"I'm the lovely sunshine
I'm the lovely sky
I'm the lovely sea that makes you look by
I'm the lovely birds that chirp with delight
Every single time you wave and say Hi
I'm the wonderful breeze that ruffles the leaves
The lovely stars that twinkle in the dark
I am the moon that makes you swoon
Especially during those times when you think of the night
I am the green grass,
On which you lay down to make time pass
I am the beautiful flowers
Looking at which can reduce your morose.
I am the air you breathe
Of course I am necessary
I blend in with all, there is nothing I cannot do
After all I am whatever surrounds you"

Jester Time

"Isn't it funny how our time is?
The way it runs in a bliss
The way it slows down during an amiss
The way it tells us what to do and what to miss
How it devilishly makes us rush
From all the assignments that are undone.
And it makes us leave all of the leisurely fun
Just to do something that needs to be done.
Sometimes it seems to run but sometimes it just stops
The confusing ways of it sometimes leaves me in shock.
What seems like an hour turns out to be a few minutes
What seems like a few minutes turns out to be an hour
It really makes me wonder if it's purely magic.
It seems so unrealistic it keeps me in a state of flounder
It being a boon or bane is up to us, blaming the clock is of no luck
Organizing ourselves is a good way to start,
So that in the end we aren't left in the dark."

Art

"I take the paintbrush in my hand
I fix the canvas on its stand
The paintbrush I hold is gently swept across the empty canvas
I use vivid colours to paint my imagination
The picture I hold is far beyond anyone's understanding
It is my own piece of work that I absolutely admire
It holds many stories from which the eyes of the beholder decides
It can be interpreted in more than a million ways combined
It may have flaws, it may not be perfect
But for me it is the best piece I have probably ever created
The way two colours blend together in perfect proportion amazes me
The way the paint just flows and how a blank canvas turns into a masterpiece
It's almost magical, it's almost unreal.
It is such a beautiful thing that I always wish to admire
Art is my passion and it is what I will always desire."

My Powerful Weapon

"My pen is a weapon with which I write
My pen holds immense power, I say this with great delight
It can do wonders, some of which you may have never seen.
It has the most spectacular abilities
The words it expresses can change someone's mind
It can be more powerful than a physical fight.
The emotions behind the writing can make one at ease
The feelings expressed can bring your heart at peace
I truly cherish my beloved pen.
It helps me fight with no blood shed.
It gives me victory, not only in terms of battle,
But also by winning a person's heart and not letting it shatter.
I don't need a gun or a knife
My defence is the words my pen writes.
I learn a lot with the help of this tool, it lets me experience great things, seeing which I bet others drool.
I can do a lot with it, write paragraphs or be poetic
I can express myself in another way, especially with those things that I fail to say
I don't know what I would do without my beloved pen, I promise to love it till the end.
I will forever admire its magical abilities
As it never fails to amaze me."

Doleful Domain

"Remember the water you wasted?
Remember the food you threw?
Remember the roof you took for granted?
All those clothes you seem to have yet you say you lack
All the money you could use yet you choose to throw
Things could be different that both you and I know
Yet you act oblivious and go into your euphoric mood
Sympathizing is easy, that even I can do. But taking action is what makes one a real hero
You think all your possessions and wealth will never go away
But you forget that there are other people who once thought the same.
Now they suffer the consequences for their selfish games."

Thank You

"Thank you for always being there for me
Thank you for always caring,
Thank you for loving me when everyone was disappearing
Thank you for supporting me in no matter what I do
Thank you for helping me no matter how busy you were too
Thank you for helping me fulfil my dreams
Thank you for never letting me give up
Thank you for listening to my problems even though you were probably fed up
Thank you for teaching me new things
Thank you showing me the right path
Thank you for letting me realize my mistakes without letting me fall apart
Thank you for never believing lies about me and always talking to me
Thank you for never holding on to those past stories.
I know once I made a mistake, I no longer will now that I have changed
Thank you once again."

Times Have Changed

"The times have changed and so have we
Those times have gone when we held on to the lovely joy of a good read
Now everyone just enough to sit and feed, till they are through with their greed.
The enjoyment of a new book or it's smell is seen no more
I just see eyes glued to their device that have become very sore
Gone the day when books were trending things now have started bending
Games are preferred over a healthy read, physical activities are put to sleep
Once there were nights when we used to hide under our blankets to read.
Now everyone takes their device and watches videos through the night
Why did it all change so much? Why did the joy end such?
I hope that someday soon, something will happen that will bring back the boon.
But until then I just sulk and hope that something can change my hard luck."

Nothing Lasts Forever

"Just like a flower in winter
Just like the way snow melts in summer
The way it gets dark without light
Then things get out of sight
Nothing lasts forever
That is the truth
Not me, not you, not anyone
It all goes away slowly slowly someday.
In the end all that is left are the dreams we dreamt,
When it's all over and it's not possible to go back
To have the things we could have, to live the dreams we could live
To see the things we could see,
To see that sunshine
To see that view
To touch those flowers
To feel the morning dew
To hear the birds chirpings with delight
To hear the leaves, rustling in flight
In the breeze of the cold night
In the end when it's all gone, then we cannot have it all
After all nothing lasts forever, nothing at all."

New Year

"A new year, a new number
A new lie why even bother
Like a paper being re-used instead of being thrown away
Nothing is great about this 'hurray'
The days are the same, the nights don't differ either
People still suffer, hypocrites still mutter
It's another 365 of misery in my eyes
I don't get the joy of the new number that you devise
Don't you realize it's all of no use?
What a useless occasion to celebrate with a joyous attitude
It's something I truly despise
And something I will never think of with shining eyes
I will continue to throw shade at this occasion that you celebrate
No matter whatever tries to come in my way."

Sagacious Thoughts

"I learnt to walk and I learnt to talk
I learnt to read, I learnt to write
I learnt everything including the way of life
I learnt how the poor suffer and how to give money the rich stutter
I learnt how peasants work and how aristocrats mutter
I saw how superior a man is and how inferior a woman is thought to be.
I saw how the big guns' pride mattered more than their dignity
I saw and I learnt and understood
I then realized that being a part of this world makes me feel absurd
Nothing is fair-be it love or war
Everyone thinks that others needs are comparatively small
All they care of is themselves
I pity the hereafter, it's going to be a mess
At the end they will be able to see
Just how selfish their needs appear to be
At least then I hope that they will feel guilty."

A Woman

"A girl- A blessing
A woman, the houses' salad dressing
A deserving being worth it all
In her eyes no task is big or small
A hard worker who never complains
She always takes away the family's pain
Her smile enough to make it shine
And drive away every sadness that comes by
She always shares her love and care
No matter what goes on in her brain
Her daily routine
Is something with which we can all not compete
The hustle and bustle never let's go of it's beat
And keeps her running on her feet.
Whenever sadness strikes the house
She is the first that comes around.
Just a few encouraging words
From her can change everything and make it work
She is truly the reason why
The whole house can stay suffice
She fulfils every need, from her housework to the meals
She deserves all the respect, and should get happiness in all aspect
I hope we all learn to see
That a woman is no less than any being
A warrior and a survivor she plays the roles well
Nothing can replace her and that is the end."

Relinquish Pain

"Don't do the mistake of hiding your pain
Smile for yourself and don't be in vain
Hearts will be broken, you must sustain
No matter how messed up it seems, it will all go away.
Find the right one to tell your problems to, so that you can pertain
Just ranting out your problems to someone will help you find a way.
Develop strength to face your problems
I promise it won't be that hard.
Don't do anything stupid like self-harm.
Mental strength is necessary no matter what situation comes in your way
Please don't give up no matter if it all seems messed up.
Doors will open, there will be a way out
Everything happens for a reason don't stress out.
Just keep trying till you finally par.
Have a nice day and I hope you always smile.
Because trust me, it will be worth your while."

Pitiful World

"The world we live in has become really barren
I cry every time whenever I look at the sky
The nature surrounding me that was once a pleasant sight
has now taken its flight.
The sounds of birds are replaced by cries of herds.
The rustling sound of trees in the pleasant wonderful breeze
has vanished suddenly
I swear the sky was blue now it has dirty grey too.
The silence is gone and so is the beauty.
The trees have been felled only scanty are left.
The ice is melting, what are we doing?
I'm sorry mother earth, your blessing of nature has spoilt us,
We took your love for granted and ruined the beauty you
bestowed upon us.
I promise to try and help, and wipe every tear you shed.
I will change the wrong doers so I can save your life.
Because there is still time until we might have to for forever
say good-bye."

I love You

"You have no idea how much I love you,
You have no idea how much I care,
Every time you go away, a part of me disappears.
You're the closest to my heart, you're the closest to everything I've got
I can't live without you, I can barely breathe.
Can't you see, you're practically everything I need?
Every hello, makes me smile wider than the sky,
Every good-bye brings me pain.
But I know, eventually we will converse again.
Seconds to minutes to hours without you, hurts me more than a stab.
But the moment we talk, my wounds heal in a flash.
Do I need to say anymore? I hope you realize I love you
You're practically the best thing I have and I would never want to lose you
Please always stay by my side, never let go.
I will always be there as your friend and never as a foe."

Can You Trust Me?

"Can you trust me?
Can you hold on to me?
Can you be my one and only?
Can you trust me?
Can you depend on me?
Can you let me help you?
Will you mind if I let go for a minute or two?
Can you trust me?
Can you pretend to not notice my flaws?
Can you pretend my past didn't exist?
That it all vanished into the mist?
Can you trust me to hide your secrets?
Can you trust me with your heart that you imprison?
Can you trust me to keep your jewels that you cherish?
Can you trust my emotions for you?
Do you trust that I will never betray you?
Let me love you, let me support you.
I hope you trust that I won't ever lose you."

Mesmerizing Eyes

"She looks at me with those beautiful eyes
The ones that possess a million stories that she hides
The pretty colour makes me stare
The charm of her eyes is really rare
I wonder what are behind those curtains that she sleep with them closed
The vibrant colours supposedly absorb the entire show.
Those eyes show expression not just of love and hate
But of feelings so strong, I know I can relate
Her tolerance is massive, you can see it in her eyes
She barely shows pain, she mostly smiles
Someday I wish I will know what all goes on in her mind
It amuses me how she always manages to stay bright
I know she suffers as well, I know she feels pain
I want to help, but I don't think she will accept
Because we aren't that close, we are quite apart
But I really wish I could fix her heart
It hurts to see her sulk and sigh
Especially in secrecy so nobody bothers her tears that seem to flow by
Seeing that sight is a sore to my eyes, because seeing her smile is an aesthetic of mine
All that I can do is admire her precious sapphire, to see them every day is my strong desire.
They seem beautiful to me no matter what but seeing them truly happy would be my luck.
I wish I am the reason for that happiness I wish I am the reason for her smiles
But apart from that desire, I just want her to be happy in her empire."

Soothing Melody

"Play the melody, teach me the tune
Let your voice reach my ears with the help of your Zune
Let me learn the lyrics that way, so I can sing along some day.
Let me feel your emotions touch my soul
With a voice so lovely my heart can't control
The bittersweet love story you sing
Is better than anything
The meaning behind that beautiful voice keeps me going with rejoice
I love listening to you, my heart skips a beat
I wish I could run a melody just like the way you breathe."

Tangled

"How do I express my emotions?
How do I tell you how I feel?
How can I show you my love?
How can I play the reel?
I want to show you that I am the one.
The one who you desire so much
If only I had the courage I would do so
But I lack that ability
It isn't easy to show you
As you are a shining diamond and I am merely a worthless stone.
Maybe we aren't meant to be together just like a princess and a pauper
Maybe all I can do is love you from afar, however my desire to hold you is very large.
I want to make you smile, I want to make you laugh.
I want you to be mine I want to take that chance
Even though I cannot provide you with material things, I can love you a lot,
I can give you more happiness than money can afford. Smiles, laughters and so much more
Everything you will have, you have my word.
My love for you is strong, so even if you don't return my feelings I will continue to love you till long."

Broken Promises-1

"Who knew this pain would last?
Who knew it would never go away?
I tried to move on but it still stayed
I now live a life of misery because of that one day
Now it's hard to get over because it's in my brain
I still remember that night of that particular day
When he walked up to me and made a promise to stay
Promises are meant to be broken, that's something I won't forget
After that day, you won't believe it but we never met.
He had conveyed his feelings for me and left
Did something happen? Not knowing is that is something I will regret
I wonder where he is, I wonder what he is doing
Whatever happened to you please let me know.
So that at least I can be at ease, knowing that you are not alone."

Broken Promises-2

"I had finally conveyed my feelings for her
I had finally expressed my love
I still remember that wonderful night of that amazing day
I had gathered up the courage and made a promise to stay
She had accepted my feelings with a smile
And I could not be more happy, no lies.
But as I reached back I got caught in a trap
Which was probably set by those who had not wanted us both to last
I was wailing in pain, I could not move in any way
As helped failed to reach me, I drowned in my pool of blood.
My lasts words undoubtedly were my words to my love
I could not regret this anymore as I had just confessed,
I hope she still smiles and about me never forgets.
I'm sorry my love, I have disappointed you
I could not keep my promise of staying beside you.
This hurts me more than it does to you
But please always be happy and also don't hate me too.
My love with you will always remain, I will protect you from the heavens every day.
Take care and farewell, now I depart. Don't cry ever as your smile warms my heart."

Wrecked

'I promise to stay with you forever'
Isn't that what you said?
Did you forget your promise to me?
Did you forget the tears I shed?
Just to make you happy just to make you smile.
I honestly sacrificed my entire life.
I couldn't believe what you had done
I couldn't understand why you had gone.
You left me alone to suffer my wrath.
Of all those who criticized our hand in hand.
I blame you for all my pain, I wish you eternal hate.
You have no idea how much I have been ridiculed
Just because I was confident of you
I thought you would never leave, I fought for our love
But in the end you betrayed me, are you that messed up?
Was I not good enough? Did I not love you dearly?
Did you not see in my feelings there was sincerity?
Why would you do this? Why would you leave?
I really never want to see your face that once gave me strong feels.
I wish I could hold an eternal grudge, I wish I could despise you
Because at the same time if you ask, 'will you forgive me alas?'
Sadly I would respond, not with fury, not with regret, but with a jar of hearts."

An Ardent Desire

"I wish that someday I can see
What this world actually holds for me
When will it be time to face reality?
So that I can believe what everyone has always told me
So that I know if it is true, not a lie not a fluke
I've been kept in this cage long enough
I'm ready to be free
I'm ready to explore
The oceans and the seas,
The flowers and the trees
The smell of the enchanted breeze
A whole new world, awaits me
I am eager to see it all, I am eager to know it all
But the patience is necessary
Or else all that I desire, will be completely out of my reach."

What if?

"If I go away will you miss me?
If I run away will you chase me?
If I get lost will you save me?
What if I go out of hand? Will you betray me?
If I can no longer breathe will you forget me?
If I can only touch but not feel will you not warm me?
If I forget, will you not remind me?
Do I still matter to you or am I just another phony?
Will you still hold my hand and tell me it's okay?
Will you care about me the same?
Will my scars bother you causing your smile fade away?
Will you feel uneasy staying by my side every day?
Will we be far apart, will we lose touch?
I never want you to stop loving me, no matter what
I would never breach your trust and I would always remain loyal
In return do you promise to keep me joyous?
No matter what nothing will change right?
Or do I have to pretend that this was another of my imaginary delight?"

Ungrateful

"I had problems and so did they
I thought mine were worse until I heard what they had to say
Here I lie on my bed, whining about my life
I have it all, big or small but I'm still not satisfied at all.
I see others who suffer in pain
Hoping that they would last a few more days
I'm such a brat because I cannot see what all this world has actually given me.
I have food, shelter, wealth, health and love
Whereas there are others who suffer for a loaf of bread
I should be thankful for I am alive,
To see others suffer is something I truly despise
To be in that position is just not right
I haven't been grateful, I will change for the better alright
As things will diminish and so will I
I promise to no longer whine and always hold a bright smile."

Poignant

"She looked out the window, she held her chest.
Things bothered her, her life was a mess.
Everyone seemed to judge, she wasn't please.
But at the same time she didn't plead.
Bitter as her life seemed, she always managed to nudge through.
Her life could be a story, this is what she kept thinking.
She had the jewels, she had a palace.
Her beautiful garden was even filled with rare clematis.
They calmed her every single day, through her window she would say:
"Oh beloved nature, I wish to be you, I also wish to touch the lovely dew,
I want to fly free like those birds and I want to stay together with a family just like a herd.
I just want to be free and I want to feel what nature has to offer me."
She shut her eyes, every single night, hoping that things would fall into place.
She had the wealth not the love and her strong will which she wasn't ready to let break.
She would definitely find a way, that is what she would say
She just wanted to be free she just wanted to learn
She wanted to see the entire earth
Her desire was strong, she would never give up.
She kept hoping for better luck.
She knew her fate would change, she knew her prayers would be answered
She was just waiting for the day when it would all happen.
She waited patiently, she didn't complain, from what I recall things ended exactly her way.

Resent

"What if I die?
Will every one lose their smile?
Will they sulk with demise at the body that has shattered behind
Will they pity the soulless mannequin that lies in front of their eyes?
Will they weep with sorrow at my suckish ex life?
Will they be able to forgive the sins they committed which hampered my mind,
Do they think that I will forgive them for all the times they have pried.
I hope they come to realize that half my life, I have only cried.
'I'm fine' I said with a charming smile, little did they know it was all a lie.
From my family to friends everything has always been a mess.
I have no regrets but I hope they do, because a part of my end lies within them."

I'm sorry

"The air in me is slowly draining out,
I'm on my death bed hear me out
I'm sorry for my crimes,
I'm sorry for those who I've hurt
I'm sorry for the times when I've gone berserk
I'm sorry to those who had to handle my pain
I'm sorry to those who had to struggle in vain
If I have wronged you I hope you forget
As I will just remain a memory filled with regret
I promise that when I was not nice, I didn't mean it, I was out of my mind
I despise myself for being impolite, please do forgive me for all those fights
I truly care about everyone, it's just that I have hard luck
It hurts to see others in pain, but my emotions don't show in an easy way
I apologize once more, please do forgive, I truly feel bad and the guilt kills.
I never once was able to tell those three words to those I truly love, i'm sorry once more for all the stupidity I've done.
Good-bye now, these are my last words, I hope eventually I am forgiven of my festers."

Will To Be Emancipated

"It's so dark in this prison
It's becoming harder to keep my vision
Please let this all be an illusion
I am unable to find a solution
Please show me the way, please show me the light
I beg of you please help me do this right
Teach me how to fly so that I can soar the sky
So that I can be free to do what I please
To live my dream for eternity
So that I can run with my own kind,
Free from the dark world that the dark people have left behind
Where I am told to wear a mask and do anything that they ask
To be perfection and to be bright,
They don't worry if I am not alright
I'm tired of this pain and of these shallow people who are all in vain
I will be free even if this kills me
I will find whatever way to run away
But I promise to not forget my values and go astray.
I will be strong and bold, I will never give up, that is for sure.
I hope I am able to survive
In the labyrinth of the world outside
I am not going to give up, it is my dream
I will now be on my way to face destiny."

A Wish

"I look out the window I see the sky
I take a deep breath and hope for something nice
I pray to thee please help me survive
It isn't easy to live a life
Don't drag me down, it will be my demise
I want to be pulled into the ray of light
I want to experience the true way of life
I want to feel the warmth of joy
I want to smile without having to cry
I no longer wish to plead for what I feel is my need.
I don't want to suffer anymore
It isn't fair, parts of me are sore
I have no tears left me, I'm drained of my energy
Enough is enough I can take no more
I just need to find the right door
The one that will lead me out of this pathetic world"

Missing Allure

"I stand in front of the mirror
I look at myself in pure terror
A once looking young face, filled with jolly and grace
Has left without leaving much trace
All that is left are the saddened eyes
With nothing but demise
A once beautiful smile, is now just a lie
The blush on my cheeks is now just a dream
The laugh that once made millions glad has changed into something sad
The eyes that once glowed, now seemingly just bellow
These are the changes I face
Because of which I have lost my grace
The old me is long gone
Now all you can see is the worlds pawn."

Who Do I Have To Be?

"Being myself I was neglected
Being another I was incarcerated.
I tried to act like a doll but I felt irritated
I tried to be a lot of things but being anyone but myself held me feeling stranded
I did everything to perfect my flaws, I did everything to change
Just so that people would love me once again
As I grew older people pointed out my flaws, I felt insecure and lost.
I tried to change as much as I could but I couldn't seem to find the thing that
pleased everyone's eyes
I ran behind another's dreams
I forgot what I wanted for me
I was busy making the rest smile
I had forgotten my own chime
Now I just try to remind who I am and where I am supposed to fly."

Churlish Networks

"I lifted them into the air
I made them shine bright, I made them flare
I gave them the limelight while I hid in the shadows
I showed them the world, I showed them what's out there
I helped them go through the tough times.
I helped them stay positive I helped them stay bright.
I was a good friend and a good person
I did everything I could in my possession
But they didn't return the favour, they just used me for their endeavour
I was thrown away like trash, like a piece of crappy paper
I wasn't treated right, I wasn't loved
All I received was hate and nothing much
I was used and played, I regret dragging this till so late
I should've ended it sooner, wouldn't it have been better?
Both the sides would've been happier earlier
Now that it's over, things have changed I still continue to succeed after I left my way
I have moved on now I'm better
I have developed an ego better than any other
I take care of myself now and I ignore the rest
I'm not being selfish I do think it's for the best
I love my new confidence I love my new strength
Now nothing can get in my way because i've reached great lengths.
I have evolved into something different, I have finally become sane
Running behind people? I have long stopped that game.
Now I have my own pride and my own ways to spend time.

I no longer need petty people in my life.
Still I would like to thank, those cold hearted people who gave me pain
After all they are the reason I changed.
I'd plead and ask to be taken back, but what a waste of time even my ego won't agree to that."

Painful Memories

"Painful memories, painful stories
Heartbroken tragedies, not any glory
Tears and pain are what are seen
Not smiling faces and Cherokees
Wounds and scars are left behind
Deepened damages still make my heart shiver fright
A wound shows the pain but a scar shows the memory of that day
I pay the price every time I smile. Thus proving that I am not permitted of that joy.
I cry and cry almost every time, what will it take to let me lead a normal life?
My life is a mess, I hate to confess
I wish people could see, I am not the nice person I seem to be
I hurt and spread sorrow
Not joy as my heart is hollow
My tragic past takes over me.
Every time I try to flee."

Exasperated

"Who knew the time would come where I would have to run
away from the problems I face every single day
I am not afraid, i'm just tired
Frustrated by peoples merciless desires
Give me a break, I am only a human
Not an angel nor a robot without a brain
I know what I have to do, I know my work.
Stop stressing me out and driving me bonkers
I have a heart and a soul, think of me as a machine? Should I
assume you to be a ghoul?
A soulless, merciless, heartless creature who spares none,
just like how you torture me to have fun.
I decided to run away, from these monsters so that I can no
longer be bothered
I went into my own world, where I am treated right, where I
am respected and given human rights
Unlike my previous life, where all that was denied.
This word where I am now seems beautiful to me somehow
It seems pleasing to my eyes, and brings my lips into a smile.
Nobody treats me like an animal, here I am treated right.
It seems unreal somehow, I truly cannot believe
Then I realize I wasn't living in reality.
Just a reverie, a part of my kip.
Of course I wouldn't have had the guts to escape, I'm still
stuck in my previous life
Living the life of Cinderella, only this time no prince charming
is going to come by."

Worthless Declare

"Who told you to tell me what to do?
Who asked for your opinion?
Did I give you permission to judge?
Who told you to simple hold a grudge?
Just because you know i'm better does it hurt?
That petty ego of yours drives me berserk
You need to get a life little twit, without you being a nitwit.
Please stop thinking about me so much
I have other who give me sincere love.
If I stay in your mind so much, you might never stop holding a grudge.
Find another way to drive me insane, because your pathetic little lies don't make my life a misery
You cannot hurt me, so why even try.
Stop simply wasting your precious time.
Change your heart and live your life.
Not in agony, not in demise.
Shake my hand, let's be friends
Because hating me will eventually take you nowhere in the end."

Hopes

"I thought I let go of the pain
I thought I let go of the sorrow
But I was wrong, I really hope my eyes don't get to see tomorrow
I hope that the sun will no longer shine
I hope that the day no longer stays
I hope that the air I breathe slowly drifts away
I hope that I soon into the darkness move
I hope that my memories turn blur
I hope everything that hurt me leaves my cognizance
I want things to be different, for them to change,
However I don't get why things don't go my way.
I wish that all those hopes come true.
So that I can run away from those people who prey
Because I feel caged between them every day."

Gaoled

"Study hard and you will succeed
These are the only words I ever hear
You block my fun, you lock me up in these cruel four walls of my house.
All I ever do is study and read
You say it will be the reason for my happiness in my late twenties
But what about now, why am I not allowed to enjoy?
Doesn't it seem wrong to you that I have no joy?
I see others who laugh and play, careless about what comes in their way
They still succeed, they are still happy.
But what about me who is losing her youth steadily.
I am old enough to step out into the world.
I am old enough to take up adventures.
Please let me out, please set me free.
Even a caged bird does not look good, do you not agree?
I never as for anything, I always listen to what you have to say.
But I am old enough now, so let me please finally have it my way?"

Buried Feelings

"Why should I lie about my feelings?
Why should I reassure others I am okay?
Are you really that insensitive that you don't want me to say?
How much do I bottle up my feelings?
How much do I hide them?
Do you not realise that even I am a mere human?
Stop considering me an angel, I am not always supposed to please others.
I have emotions too which I sometimes need to express
Just because society doesn't approve it is none of my disquiet.
I need to vent out what I sometimes feel.
Please try and understand, please try to think, I cannot always be smiling.
I have things going on in my life, I have issues too.
Just because I am young doesn't mean they are not as serious as what you go through.
Things can trigger me in different ways, not everything has to be a joke.
Maybe what may seem funny to you might hurt my soul.
Even then you wish that these feelings I must bottle up?
I want to tell people how I feel, I want them to know when they hurt me.
I want them to understand I am not perfect, I want them to get me.
How do I say all this when you want me to shut up?
I wish you would just let me be and let me express my emotions freely

By now those emotions inside of me have grown to the point where I really can't control
There will be a day when I have an outburst then what will you do?
When I go wild and crazy and show everyone just how much of a human I am too."

www.ingramcontent.com/pod-product-compliance
Lightning Source LLC
Chambersburg PA
CBHW021046180526
45163CB00005B/2312